MASTERS OF WORLD PAINTING

Antoine Watteau

HARRY N. ABRAMS, INC., PUBLISHERS, NEW YORK
AURORA ART PUBLISHERS, LENINGRAD

TEXT BY MIKHAIL GUERMAN
TRANSLATED BY IAN McGOWAN
DESIGNED BY VIACHESLAV BAKHTIN

Library of Congress Catalog Card Number: 79-55127
International Standard Book Number: 0-8109-2221-5

Copyright © 1980 by Aurora Art Publishers, Leningrad
All rights reserved. No part of the contents of this book
may be reproduced without the written permission of the publishers

Created by Aurora Art Publishers, Leningrad,
for joint publication of Aurora and Harry N. Abrams, Inc., New York

PRINTED AND BOUND IN THE USSR

Watteau has long had the reputation of an artist more refined than profound, of the melancholy and sensitive poet of the age of gallantry, and to a large extent this reputation remains with him today. The cool shady atmosphere of a park, the play of gold, lilac, and coral-pink silks against the fresh grass of a lawn, the dulled marble of statues above artificial waterfalls, the graceful gestures of cavaliers and their ladies, who seem to be moving to the ceremonial music of Chambonnières — this charmingly unreal world, brought to life by the artist's brush, disposes the viewer to dreamy contemplation, to associations which, if pleasant, are close to being banal, and are only very tenuously related to the essence of Antoine Watteau's art. This conception was fostered in many ways by the artist's imitators, who brought the external elegance of their borrowed devices to complete but impersonal perfection. All this complicates the understanding of the artist's work as he intended it, and of the originality of his towering, exceptional talent.

However, it is scarcely possible to penetrate the world of Watteau without bearing in mind the traditional conception of him. It is not necessary to divorce the artist completely from conventional associations or from his age, and one must not seek in his pictures the confused spiritual tension and psychological complexity typical of twentieth-century man. It is much more important to determine the nature of the painter's attitude to his own time, and to appraise his deeply personal, sceptical, and at the same time exultant perception of a life which he could brilliantly re-create, but in which he was fated not to take part.

Probably the most acute of the tribulations Watteau had to bear was his own constant and well-founded conviction that his art would never be completely understood and valued. Genuine recognition was rare; more often he met with condescending approval, and more often still with indifference. Few guessed the real significance of this artist's talent.

Like many others, he set off for Paris as a young man to find both a job and someone to teach him, and to see the works of the great masters. His birthplace was Valenciennes, a provincial town more Flemish than French, where artists were few and far between, and where the totally insignificant painter Gérain, Watteau's first tutor, was considered a celebrity.

Jean-Antoine Watteau, the second son of Jean-Philippe Watteau, a prosperous tradesman and householder, was born in 1684. His father, according to the city records, was an insufferable person and given to drink, for which he was repeatedly penanced by the Church and even served time in jail; no doubt he was harsh with his son. He raised no objections, however, to Antoine's desire to be a painter, though he soon concluded that the painting lessons were too expensive, and these were accordingly discontinued. Antoine had now nothing to gain by remaining in Valenciennes, where, moreover, he risked being called up for military service; so he left home and made his way, on foot, to Paris.

In Paris his devotion to art was severely tested. Day after day he worked in a shop on the Pont Neuf, making copies of pictures for ridiculously small sums. Here art was reduced to a trade and subjected to continual degradation. Nevertheless Watteau found the strength to draw in the evenings and on Sundays. This period produced his *carnets* — miniature sketchbooks in which his pencil captured moments in the twirling kaleidoscope of the capital's life with an artistry surprising in a man of so little experience. In this random bustle the artist seeks out all those things close to the nature of art itself — plastic movement, the expressive rhythm of a dress's folds. He loved to draw buffoons, delighting in the perfection of their postures and the precision of their movements practiced over the centuries. For him there was no sharp dividing line between life and art. He, a poor apprentice, was set apart from the full-blooded, coarse, overwhelming reality of Paris. Watteau, the timid dreamer amongst the crowd, watched the stage of a market theater and forgot his poverty, his continual ill-health, his painful shyness, and took part in this wonderful theatrical life from which the prosaic was banished.

In the shops of the Rue Saint-Jacques he looked at prints, on the Pont Neuf at paintings. This was even more fascinating than the theater. The young artist was fortunate enough to meet and be noticed by Jean Mariette, a print dealer and himself no mean engraver, a connoisseur and a patron of art. Watteau was now able to enter the milieu of painters, men of letters and poets. For the first time he came into contact with the intellectual elite of Paris.

This was a time when, in the words of Herzen, "the marvelous, powerful, energetic eighteenth century could already be glimpsed. Nations began to discover themselves; Montesquieu was already writing, and the air was heavy with the approaching storm." It would, of course, be unforgivably naive to search the drawings and paintings of the young artist for any connection with the ideas of the Enlightenment or for concrete presentiments of "the approaching storm." All the same one can sense the changing moral climate, the desire of thinking people to observe life and themselves without the pompous schemes imposed by the official art of the outgoing seventeenth century. The growing mistrust of simplistic and grandiloquent judgements could not but be noticed and absorbed, if only intuitively, by Antoine Watteau. A melancholy and ironic attitude to reality was growing in enlightened circles. Montesquieu showed Parisian life through the eyes of his unsophisticated, but perspicacious Persians, and the absurdities of the *beau-monde* were made clear with tragi-comic obviousness. Scepticism of thought entails an unavoidable string of doubts, and gives rise to a mocking attitude to the present and even to the future. In Mariette's home, and from his new teacher, the stage-set designer Claude Gillot, Watteau absorbed, if not whole philosophical systems, at least the ideas and opinions aroused by them. Irony became the constant companion of his art.

The earliest of Watteau's pictures in Soviet collections is the *Satire on Physicians*, painted after several years' work first with Gillot, and then with Audran, a most experienced painter of decorative murals. Here the surface irony is obvious, but already it is possible to discern the artist's desire for a complex, multilevel perception and re-creation of reality. He was painting, in fact, a common marketplace spectacle, one which brought to mind the comedies of Molière. A crowd of doctors, armed with monstrous clysters, attack a terrified patient. But the trees, touched by the evening sun (or skillfully lit by theatrical lamps), the twilight sky, resembling a painted backdrop, the painstakingly contrived but muted harmony of the costumes, rust-red, greenish-brown, gray-blue (amongst which two bright spots stand out, carmine and gold) — all this makes the projection of a theatrical atmosphere, a mixture of gaiety and anxiety, the main motif of the picture, in which farce is only an unimportant element. From his very youth the artist rejected simple solutions, and in this early picture he exults, and laughs, and is sad. Reality's paradoxes were already becoming apparent to his sensitive mind, and later the characters in Watteau's pictures could no doubt have said with Montesquieu, "We are so blind that we do not know when we should be sad and when happy. Almost always we give ourselves up to false sorrow or false joy."

4

Watteau became a more and more experienced observer. In Mariette's house, in the studios of Gillot and Audran, behind the scenes at the theater, in the homes of learned collectors he saw a life which might have been foreign to him, but was endlessly diverting and seething with ideas. He listened to conversations full of brilliant and sophisticated argument. And finally he saw the work of the greatest masters and studied paintings by Rubens in the Palais de Luxembourg (Rubens became his favorite artist).

Condemned from his youth by illness and shyness to constant spiritual loneliness, and not seeking any vainglorious worldly success, Watteau still nourished the dream of creating something great from the point of view of the prevailing official taste, and recklessly began a large canvas on a Biblical theme, a fixed condition of entry in the Academy competition for the *Prix de Rome*. But Watteau was unable to masquerade as a safe traditionalist; he failed to win first prize, and in a fit of bitter despair he returned home to Valenciennes.

Apparently unable to recognize that precious quality of his own talent, his individuality, he underwent an agonizing spiritual crisis, intensified by the unavoidable humiliation of his ignominious return to his home town. In a few months he reappeared in Paris.

The impressions of his journey home, entirely unlike those gained in the capital, forcefully struck his imagination. His route had enabled him to see French troops, in their dirty white uniforms and with dust-covered faces, on their way to the troubled Flemish border, and to hear the voices of the officers, hoarse from fatigue, and the dreary creaking of cannon-wheels. When he began to paint the small pictures now known as "war scenes," he could scarcely have been counting on their success. They were too personal, too far from the accepted traditions of battle painting, and even a certain resemblance to Flemish genre paintings did not hide elements of innovation which perplexed the connoisseurs.

These small pictures, painted on copper, are an unusual combination of pastoral decorativeness and a cold, aloof sadness. The artist does not scrutinize the faces of the soldiers marching or resting in their bivouac; he regards their bowed and fatigued figures from a distance, with a silent, calm sympathy. Watteau's brush, ever eager to search out the attractive in any theme, avidly picks on the severe picturesqueness of the subject: the coarse cloth of the uniforms, the dull gleam of the gun muzzles, the field cloaks, and even the ground at dusk — all seem to radiate a restrained but many-hued light. And the beauty

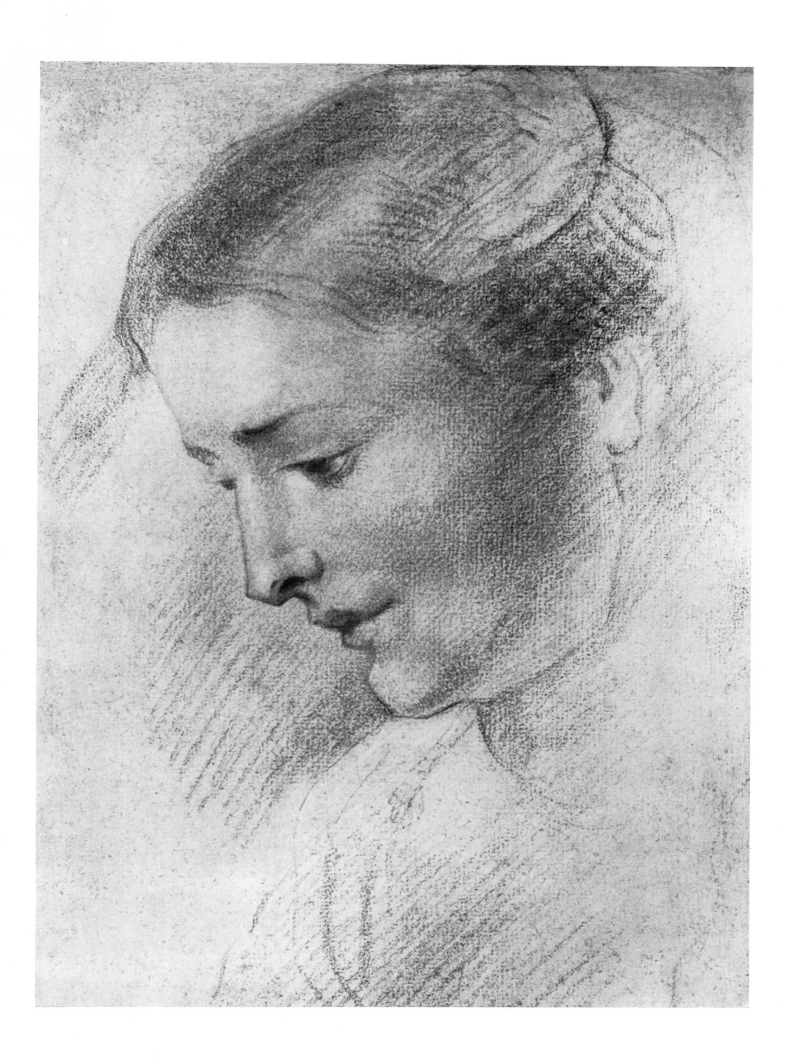

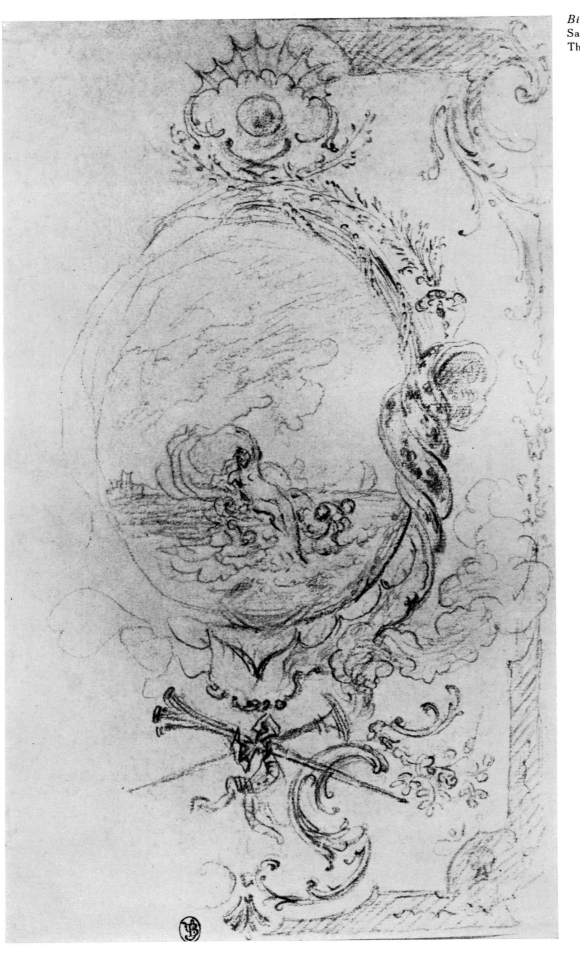

Birth of Venus
Sanguine. 29.5 × 17.5 cm
The Hermitage, Leningrad

of the world, foreign to the soldiers, emphasizes their estrangement from the true joys of existence, from which they are forcibly torn by war.

For the first time the battle genre acquired a philosophical foundation, thus answering the taste of the age. Contrary to expectation, the pictures were successful and purchasers were found for them immediately. In the short period following his return to the capital Watteau had already managed to jolt the prejudices of the Academy — he was awarded the title of *Agréé*, the lowest rank in the academic hierarchy.

Watteau was already known in artistic circles as a subtle and quite original master, and his pictures were already becoming fashionable; only one more step was needed to turn him into a pampered salon painter. But Watteau simply could not play this role; his life was too full of inner tension, too lonely and difficult. Not that he regarded the "society rabble" with proud contempt; on the contrary, he found much to admire. But although he loved carnivals and masquerades, he remained an observer.

There were only a few close friends whom he saw and painted in a different manner, forgetting that poetic aloofness with which he regarded the life of the rich bourgeoisie. In the picture housed in the Hermitage in Leningrad and known as *Actors of the*

7

Comédie-Française, Watteau combines portraiture with a striking feeling for the picturesque. The rounded, resilient brushstrokes seem to have been applied with the lightness of spontaneous improvisation, yet at the same time with a bold precision which only a mature master could command. The faces, showing fatigue, animation and faint anxiety, are illuminated by a mysterious theatrical light, the fantastic costumes shimmer with wine-pink tones against the black velvet of the masks. All this creates an impression of the natural unity of the imagined and the actual, a Hoffmannesque world where the characters' reality is only enhanced by the strangeness of their surroundings.

The artist's melancholic, almost misanthropic nature, together with his morbid psychological sensitivity, would not allow him to tolerate the company even of his closest friends for long. He was, as his contemporaries and friends wrote, "a good though difficult friend," "a derisive and caustic critic, always dissatisfied with himself and with others." One of the richest men in Paris and a patron of the arts, Pierre Crozat, who had gathered in his hôtel a wonderful collection of paintings and drawings by the Old Masters, invited Watteau to work in a magnificent studio there. But even he was unable to retain the artist for any length of time. Watteau preferred independence to the untroubled but circumscribed position of a "Court painter."

However, it was here, in Crozat's house, that Watteau came into contact with that world which he alone was to comprehend in all its tragic contradictoriness. "There is nothing more exciting than a stroll (if I may thus express myself) through the thoughts of the people around one," wrote Mercier in his *Tableau de Paris*. "Then you see that often a person's clothes will tell you more than the person himself; sometimes a man will respond to your conversation not on your plane, but on his own; but his answer will be none the less revealing. A gesture which replaces words is at times amazingly expressive. Any lapse of memory or learning can be corrected with the help of a thousand such trivialities, and the society in which you move will teach you more of people and the world than any book." Nothing could give a better idea of the atmosphere Watteau breathed than these words. At Crozat's extravagant *fêtes*, Watteau, even though he took no part in the general conversation, could deduce from the guests' gestures the sense of their words. He interpreted what he saw as a graceful pantomime, played out to the scarcely audible music of the harpsichord. If Watteau, like his successors, Lancret, Pater or Saint-Aubin, had contented himself with an enraptured replication of reality, the complete embodiment of his dream world could have been found here, in concerts, carnivals, firework displays rivaling those of Versailles,

frivolous hoaxes and learned discussions in the deep shade of parks decorated with statues, or in salons hung with famous paintings. But Watteau was an artist of quite a different order.

His predecessors, especially the great Poussin, did not differentiate between the subject of a painting and its mood. The heroic was always sublime, the poetic affecting. The action of a picture and its emotional content were never at variance.

In Watteau's pictures, however, there is always a distinction between the subject and the characters' feelings on the one side, and the attitude of the artist on the other. His was indeed an age of paradoxes. The comedies of Marivaux gave birth to the term "marivaudage" for a brilliant exchange of witty and unexpected *doubles-entendres*. Le Sage's *Diable boiteux* could see into houses through roofs and walls, and observe people's secret lives. The story of Manon, a woman who combined great virtues with equally great vices, was soon to become famous. Watteau's art developed along a similar path of elegant and elusive, though less sharply expressed contradictions.

His world resembles an eternal masquerade, where not only faces but feelings are disguised and the faces preserve the inscrutable cunning of coquettish velvet masks. In fact, for several years masks were in fashion, despite the official disapproval of Versailles. These prohibitions frightened no one. On the contrary, license and mystification were the prerogatives of the new age.

Watteau's characters' attitude to themselves is as complex as their attitude to the surrounding world. Mezzetin, accompanying his mournful serenade on a guitar, is like an actor of the Commedia dell'Arte who plays himself. His sadness is emphasized in a purely theatrical way, and the contrived elegance of his pose makes it difficult to take the situation seriously. But the marble statue, turning indifferently from the suitor, introduces into the picture an unexpected note of poignant and genuine sadness, not realized perhaps by Mezzetin, but keenly felt and expressed by the artist (*Mezzetin*, Metropolitan Museum, New York).

Watteau's characters are unable to give themselves up to a single mood, and he treats their irresolution with an ironical condescension, at times tender, at times cold. *La Boudeuse* (Hermitage, Leningrad) would seem to be a picture almost anecdotal in theme: an affected, somewhat doll-like heroine, a languidly persistent would-be seducer, a regular landscape resembling a stage decoration. There is, however,

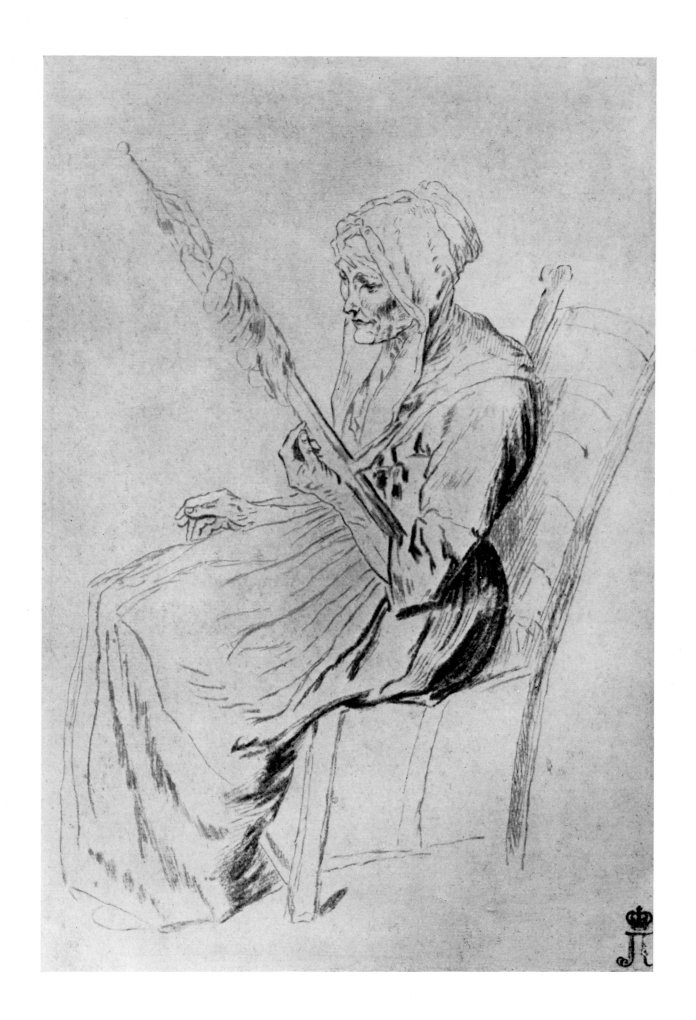

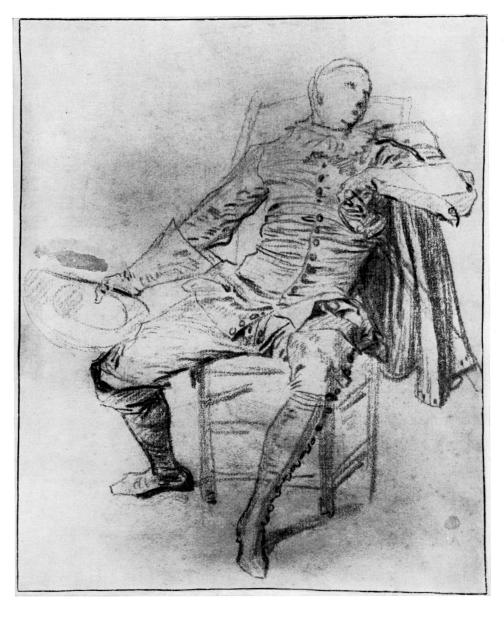

Crispin Sitting
Sanguine. 21.5 × 17.2 cm
The Pushkin Museum of Fine Arts,
Moscow

something illusory and unreal about this hot-house atmosphere of artificial emotion. The characters enact the pantomime of their own fate, to which they are in fact totally indifferent. The landscape, suffused with the tender light of the sun, partly obscured by cloud, brings to mind the words of John Constable about one of Watteau's pictures — that it was "as if painted in honey." Nevertheless, the dark violet tones of the young woman's gown clash with the matt gold of the peaceful landscape, and with the ash-pink of her companion's coat. And this dramatic quality of the color makes one feel the invisible presence of the artist himself, divining in his characters' helpless vulnerability their preordained incapacity to understand either the true beauty of the world, or the frailty of their own ephemeral existence.

Watteau was expressing in shapes and colors an ineffable, but a deeply poetic conception of the world. Ineffable, but all the more convincing because of this.

Sometimes only a long acquaintance with one of his pictures permits one to discern the emotional duality and constant alertness of an artist who never allowed himself to be lost in rhapsodic contemplation. The painting *An Embarrassing Proposal* (Hermitage, Leningrad), like *La Boudeuse*, at first sight appears to be merely a courtly scene. There is no color tension here, no surprise of rhythm; the artificiality of the languidly graceful movements imparts a sense of unreality to this too beautiful world. Thus does a waking man sense the disappearance of an enchanted dream.

Watteau does not insist on the strict verisimilitude of the scene. His picture is simply an emanation of prosaic reality. The "real thing" is Watteau's art: the calm rhythm of movement, the harmony of human emotions, a rainbow chain of multicolored costumes against the background of a misty, green-blue landscape. The plastic world of the artist makes itself keenly felt in the rounded forms, built up with delicate but ener-

getic brushwork, in the pearly haze in the air, into which lines and tones soften and fade.

Whatever Watteau painted he made no conscious compromises, but all the same the taste and demands of the Academy shook the artist's confidence in the unquestioned rightness of his style. Working on the large canvas, *Embarkation for the Island of Cythera* (Louvre, Paris), he did perhaps some small violence to his talent and created a grandiose spectacle, alien to his restrained and intimate style.

The island of eternal and perfect love, Cythera, becomes in Watteau's picture the abode of his characters' finally realized dreams. The lovers, conversing idly, stroll beneath the trees, as if to the rhythm of an inaudible minuet. But the transitory complexity of these amorous relationships, the hesitancy of the ladies and the diffident insistence of their cavaliers, unfailingly resolve into happy and tender accord. The rose-decked statue of Aphrodite looks down condescendingly at the lovers, cupids gambol in the sea air, and the whole picture is the apotheosis of a lyrical, yet still amusing spectacle. The subject's conventionality and coquettish solemnity are, however, softened by the rhythmic subtlety of the procession, just as the multicolored costumes and the pale green of the trees are softened by a light haze.

It was this picture that brought Watteau the rank of Academician, although qualified with the specially invented title of Painter of *fêtes galantes*, which gave him an anomalous position among the members of the Academy, and was a persistent reminder that there must be something inferior in an art so individual as to defy categorization.

In this way official recognition was, with some reservations, conferred on Watteau. His pictures met with growing success. The Regency period accepted a morality which, if only for appearance' sake, had previously been denied by Versailles. As Pushkin wrote of this time, "The closing years of Louis XIV's reign, which had been distinguished for the strict piety, gravity and decorum of the Court, had left no trace whatsoever. The Duc d'Orléans, who combined many brilliant qualities with all kinds of vices, unfortunately did not know what it was to dissemble. The orgies of the Palais-Royal were no secret in Paris; the example was infectious. ... Greed for money was united to a thirst for pleasure and dissipation; estates were squandered, morals foundered; the French laughed and speculated — and the State was going to ruin to the lively refrain of satirical vaudevilles.

"Meanwhile, society presented a most remarkable picture. Culture and the craving for amusement had brought all ranks together. Wealth, charm, renown, talent or mere eccentricity — everything that fed curiosity or promised amusement was received with equal favor. Writers, scholars and philosophers left the quiet of their studies and appeared in high society, to do homage to fashion and to dictate to it." *

But, as before, Watteau stood apart from these new tastes. All flippancy was alien to him, and he did not wish to squander his diverse and vital spiritual dynamism on frivolities, no matter how refined. He chose for his pictures that which corresponded to his own standard of the beautiful, and because of this his choice perplexed many people. He did not paint Paris, for example, although he was a Parisian through and through, as is demonstrated by his poetic scepticism, and his irony suddenly changing to a diffident lyricism. But he would enthusiastically paint a beggarboy from Savoy, a tramp with a marmot and a pipe. In *Savoyard with a Marmot* (Hermitage, Leningrad) Watteau forgot the mirages of the *fêtes galantes*, and revealed his still unexhausted store of love for the deprived, for people perhaps less successful than himself, but almost as lonely.

There is a slight affinity between *Savoyard with a Marmot* and another of Watteau's masterpieces, *Gilles* (Louvre, Paris). *Gilles* (known also as *Pierrot*) is that special type of painting in which the most important feature is not a person's portrait in the direct sense, but the representation of his spiritual condition. Although the face and figure are painted in frozen and tormented immobility, Pierrot's inner life is disclosed to the viewer with piercing force. The viewer feels himself to be the only witness of the actor's plight, and it seems that only the viewer hears his silent confession. Pierrot exists in a strangely dual world — on the stage, where he remains the eternal failure and favorite of the crowd, and at the same time in everyday life, where he is infinitely lonely. Pierrot's shapeless white costume makes his body seem flat and almost incorporeal, and so even more helpless. Only the striking richness of the soft ocher, silver-violet, gray and dull blue brushstrokes which make up the white costume brings one back to the world of the theater and of art, to that mysterious world of the beautiful from which Gilles's joys and sorrows are inseparable, as were those of Antoine Watteau himself. In this way one can glimpse the hidden, most personal theme of the artist, whose existence was just as ambiguous as that of the actor who offers joy and escape to everyone but himself, and lives in a magic world of his own creation.

However fantastic Watteau's compositions might have been, they were always the result of painstaking work from nature. The artist's drawings are brilliant. As the Goncourts, the first serious students of Watteau's work, wrote of his drawings, "The externals,

* Extract from *The Negro of Peter the Great* (*The Queen of Spades and Other Stories* by Alexander Pushkin, translated by Rosemary Edmonds, London, 1962).

SATIRE ON PHYSICIANS
(QU'AI-JE FAIT, ASSASSINS MAUDITS?). 1708—9
Oil on panel. 23 × 37 cm
The Pushkin Museum of Fine Arts, Moscow

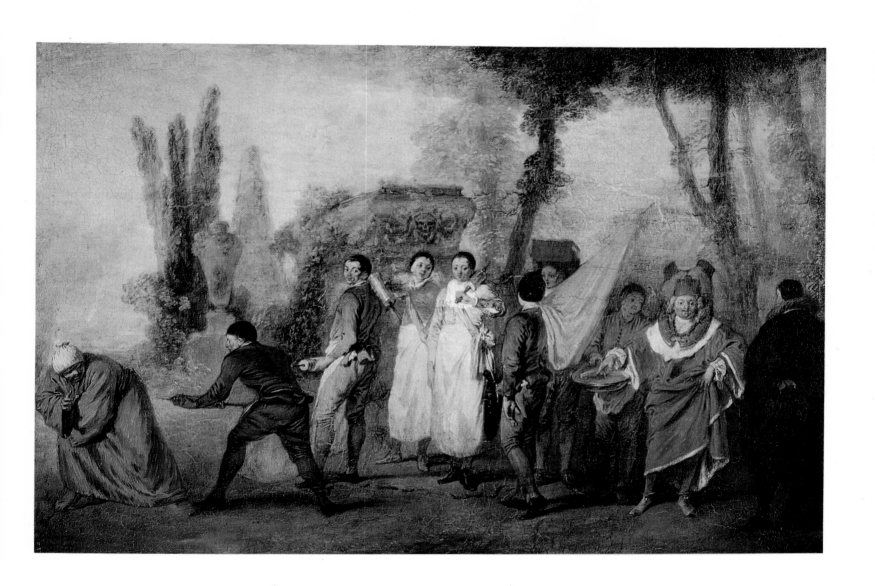

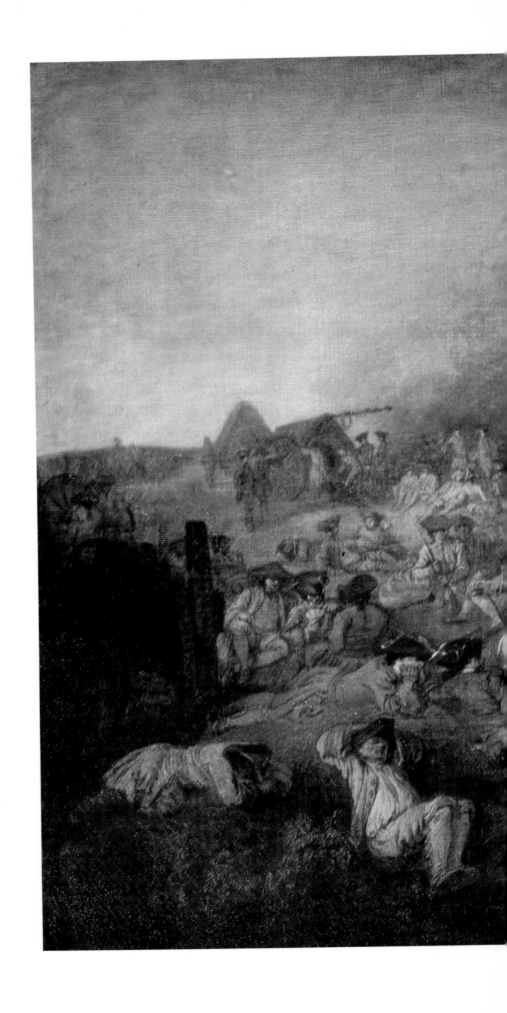

THE BIVOUAC. *Ca.* 1710
Oil on canvas. 32 × 45 cm
The Pushkin Museum of Fine Arts, Moscow

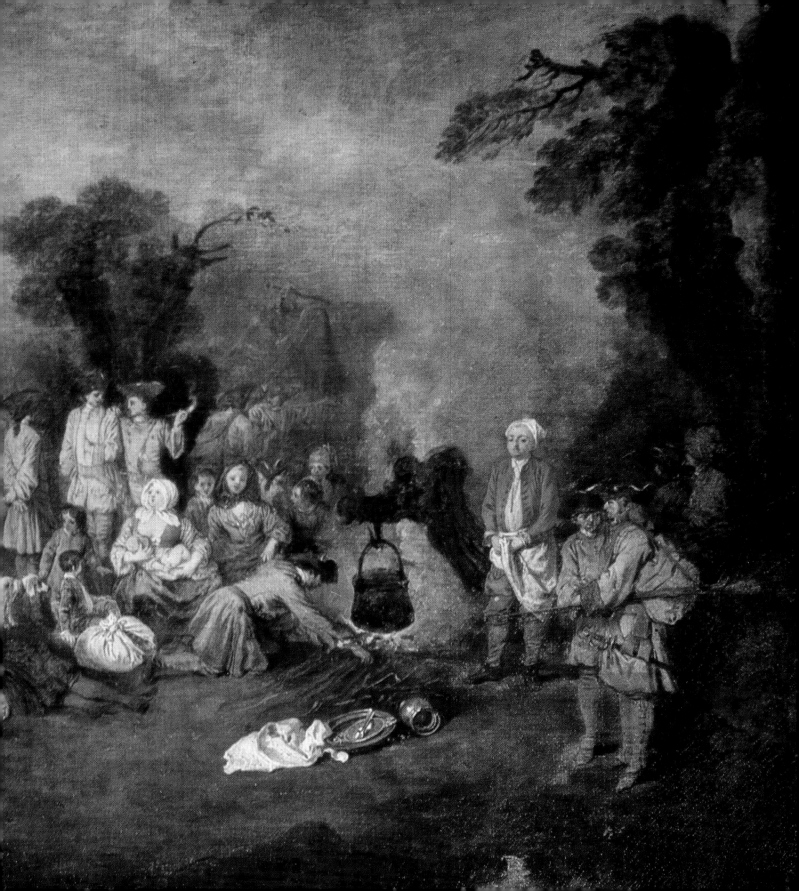

ACTORS OF THE COMÉDIE-FRANÇAISE. *Ca.* 1712

Oil on panel. 20 × 25 cm
The Hermitage, Leningrad

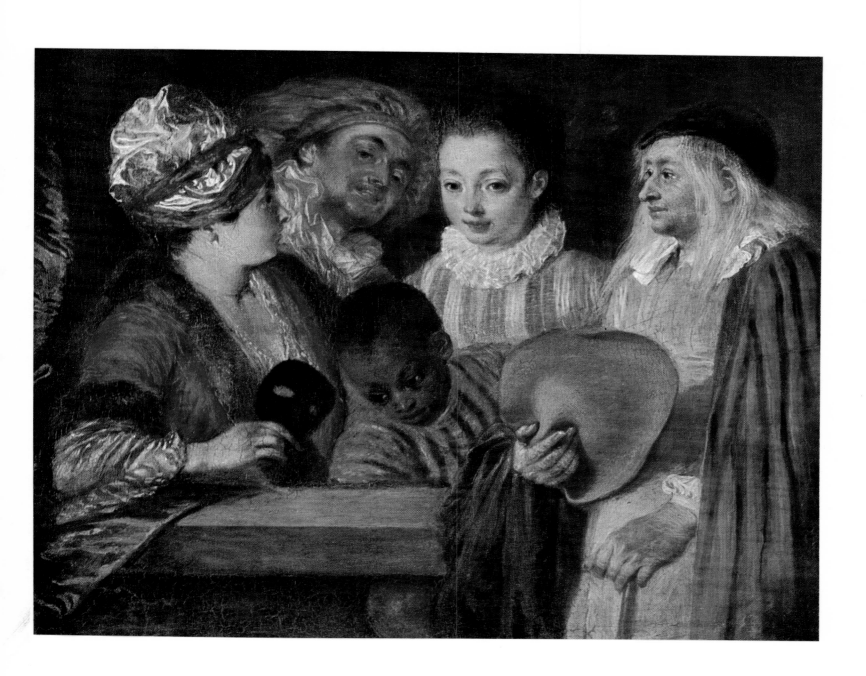

ACTORS OF THE COMÉDIE-FRANÇAISE. Detail

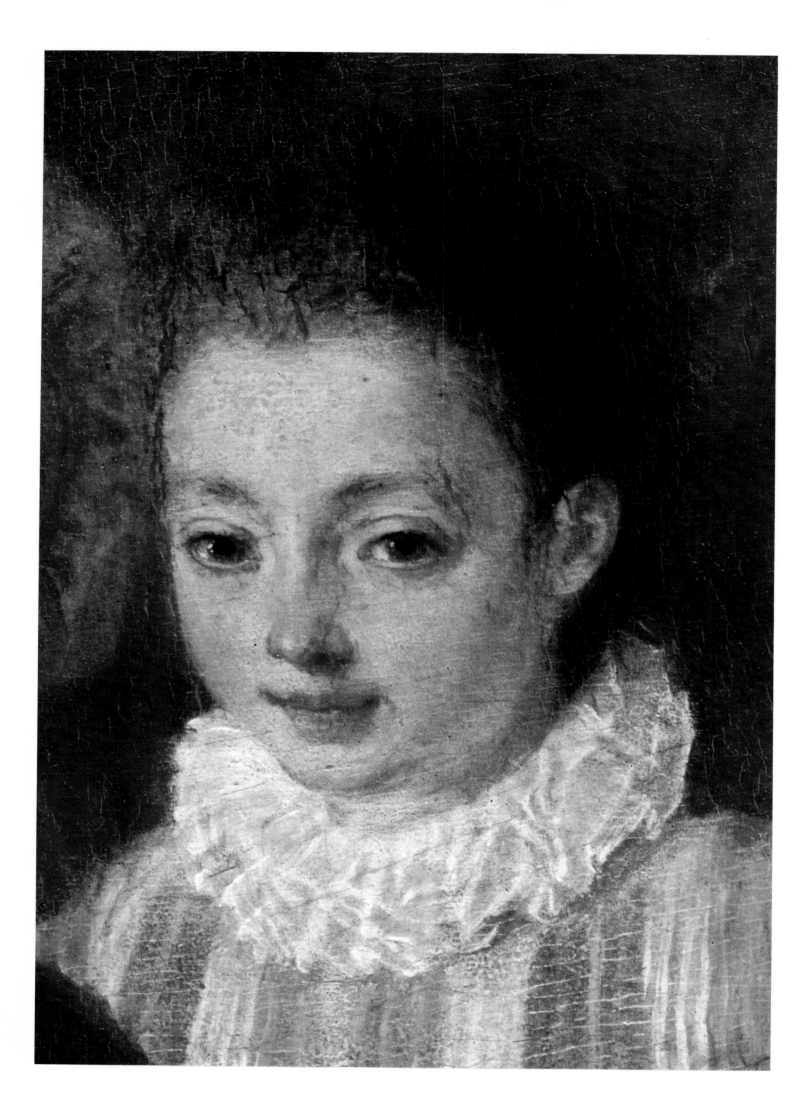

THE HARDSHIPS OF WAR. 1715
Oil on copper plate. 21.5 × 33.5 cm
The Hermitage, Leningrad

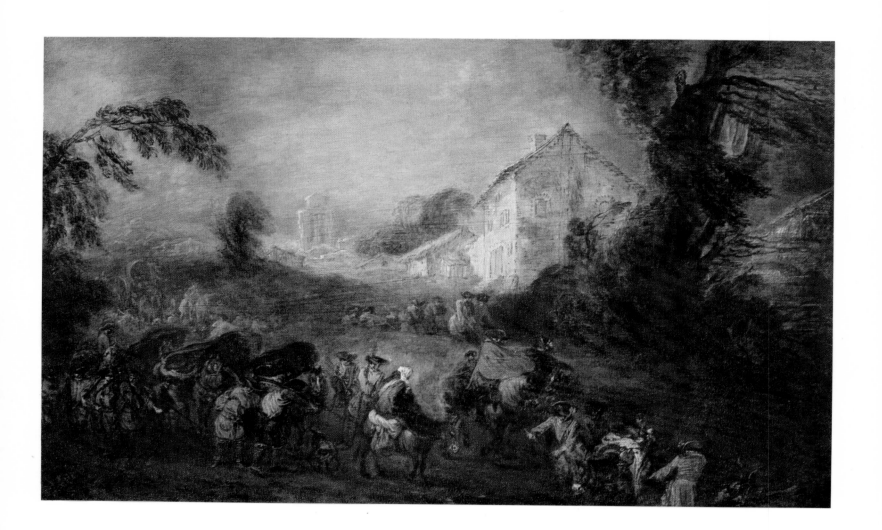

THE HALT. 1715
Oil on copper plate. 21.5 × 33.5 cm
The Hermitage, Leningrad

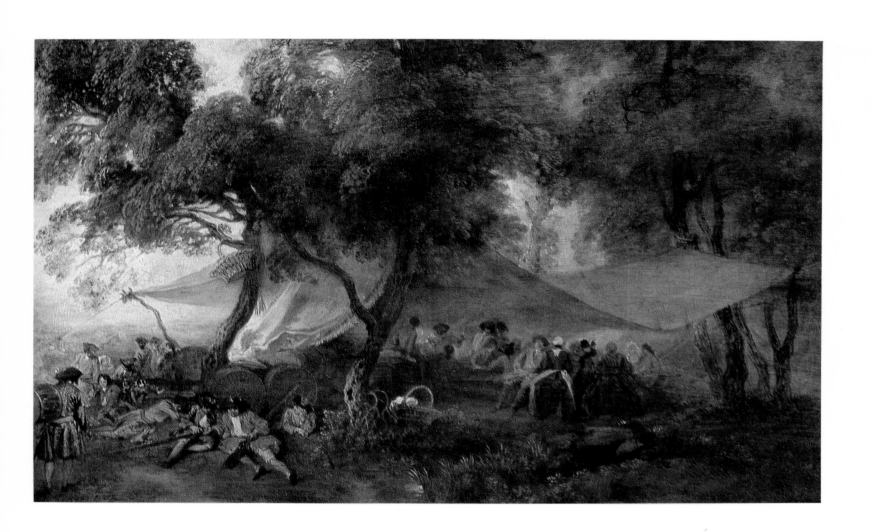

THE HALT. Detail

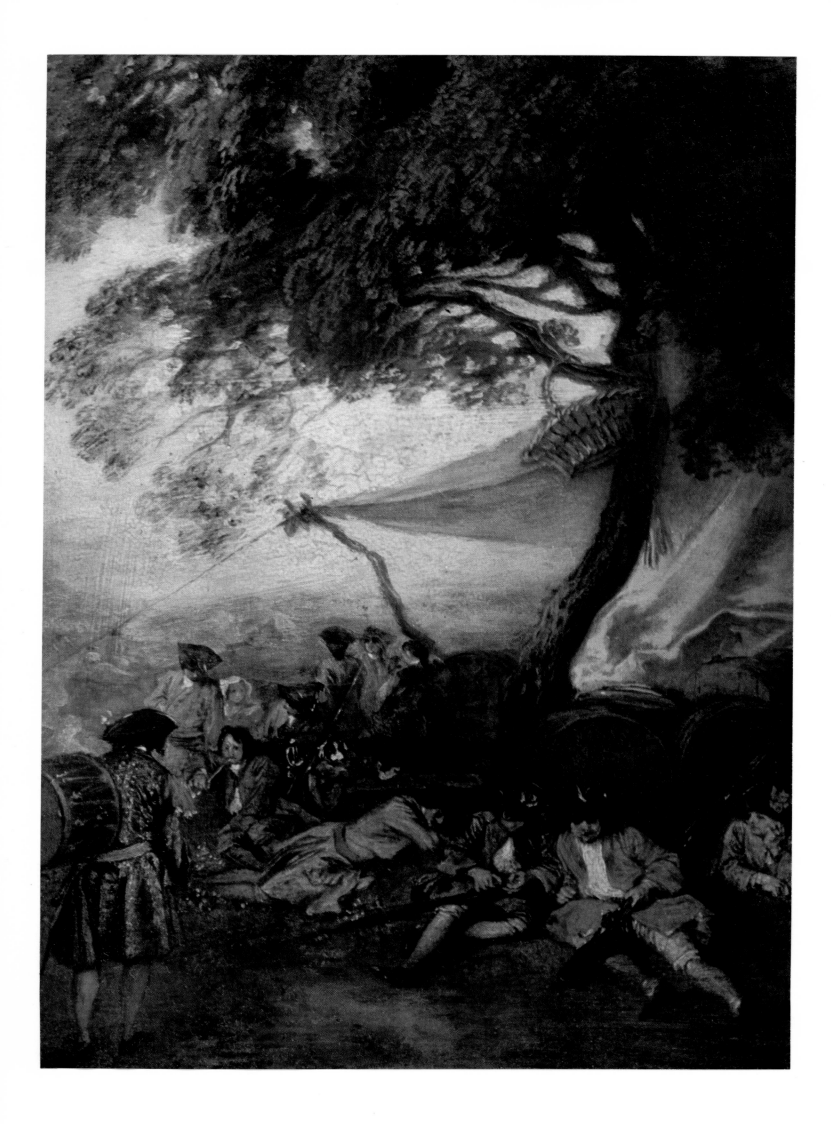

SAVOYARD WITH A MARMOT. 1716
Oil on canvas. 40.5 × 32.5 cm
The Hermitage, Leningrad

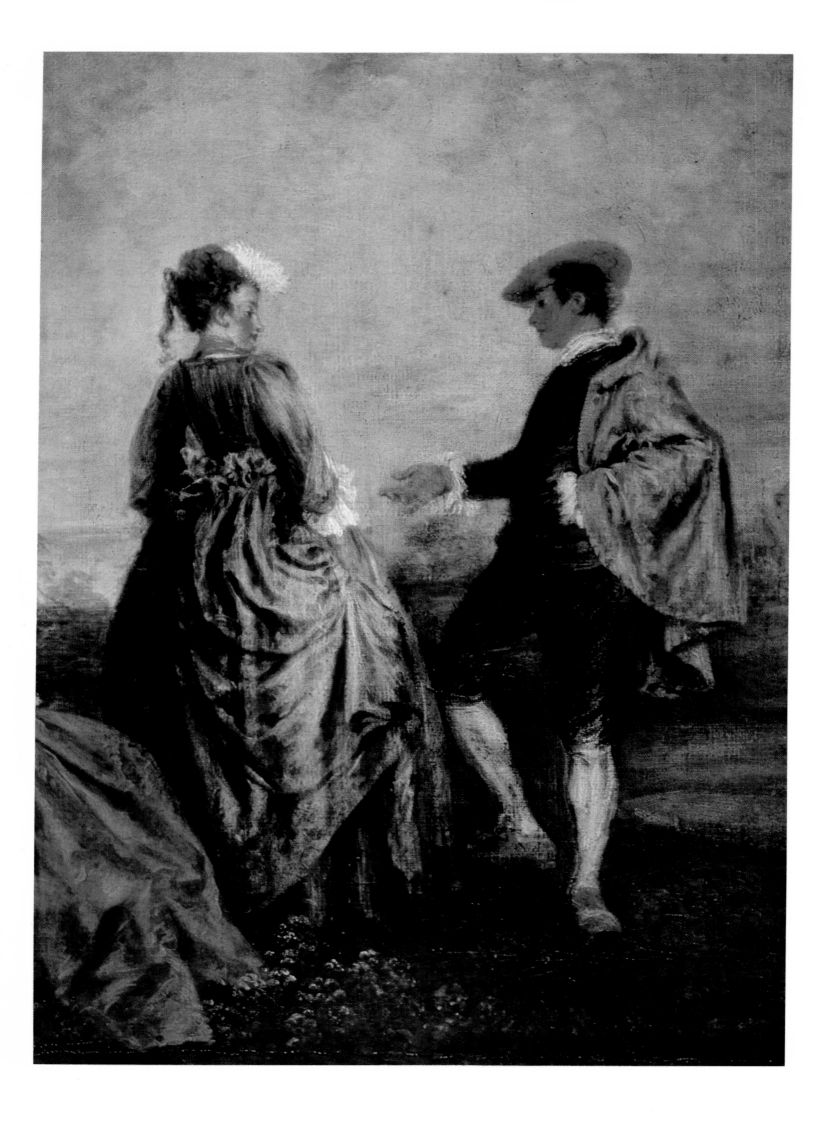

LA BOUDEUSE. *Ca.* 1718
Oil on canvas. 42 × 34 cm
The Hermitage, Leningrad

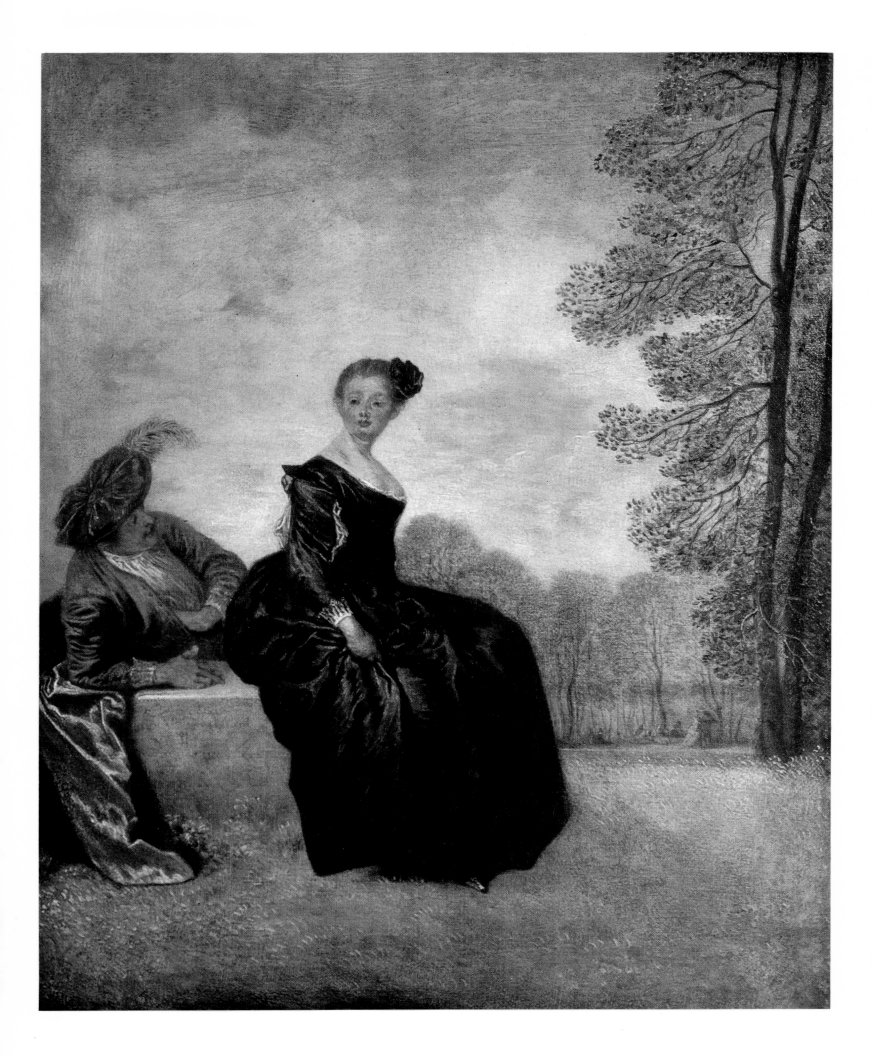

LA BOUDEUSE. Detail

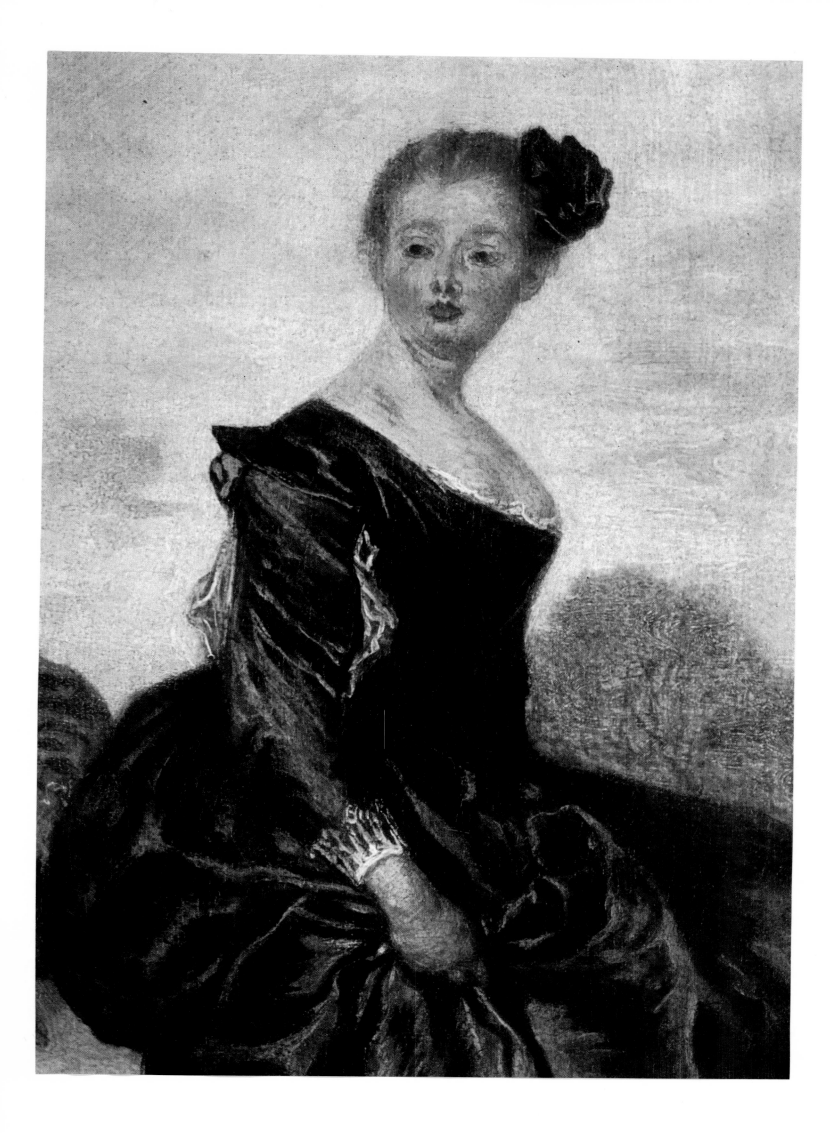

LANDSCAPE WITH A WATERFALL.
Ca. 1714—15

Oil on canvas. 72 × 107 cm
The Hermitage, Leningrad